THE LINDISFARNE PAINTING BOOK

Aidan Meehan was born and educated in Northern Ireland. After leaving Belfast in 1973, he discovered a deep interest in Celtic art, which led to his eight-volume *Celtic Design* series, followed by his *Celtic Patterns Painting Book*, *Celtic Alphabets*, *Celtic Borders* and *The Book of Kells Painting Book*, also published by Thames & Hudson.

THE LINDISFARNE PAINTING BOOK

Aidan Meehan

Thames & Hudson

First published in the United Kingdom in 2000 by
Thames & Hudson Ltd, 181A High Holborn, London WC1V 7QX

British Library Cataloguing-in-Publication Data
A catalogue record for this book is available from the British Library

ISBN 0-500-28184-X

Printed and bound in Spain

Contents

	Introduction	7
Folio 002v:	knots, birds, dogs and mazes	8
Folio 003r:	birds	20
Folio 011r:	birds and knots	26
Folio 017v:	dogs	34
Folio 027r:	dogs and birds	46
Folio 029r:	birds	50
Folio 095r:	dogs	52
Folio 211r:	dogs	56
Source Books		64

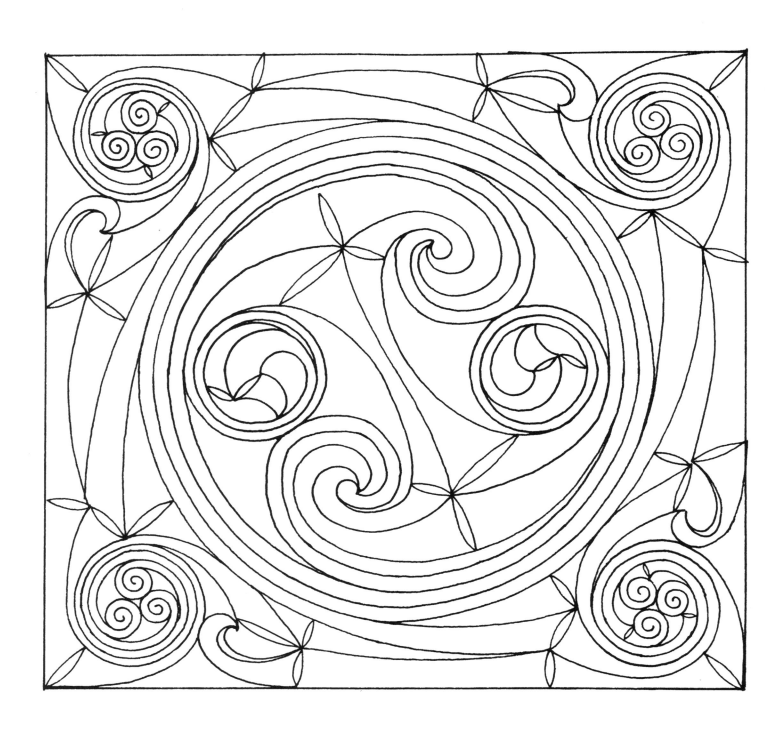

Folio 094v, a1

These fifty-seven drawings from the Lindisfarne Gospels can be
coloured in easily. Originally minute, they have been redrawn to
fit the pages of this book. The integrity of each design has been
preserved, but where a pattern was woven together with other
patterns, it has been reworked, so that it stands alone.

The original manuscript page from which each design is derived
is given. Recto (r) refers to the right-hand page, or the front of a
manuscript page, and verso (v) to the left-hand page, or the
reverse of a manuscript page. Except for the spiral, opposite, the
designs are presented here in the order in which they originally
appeared in the Lindisfarne Gospels. Look through all of them and
pick out the simpler ones and paint them first.

The paint used in the Lindisfarne Gospels was tempera – pigment
hand-mixed with egg white. The closest modern equivalent is
acrylic, but modern tempera, watercolour, or designers' gouache
may also be used. You can paint over acrylic, gouache and tempera,
which is helpful when trying out colours. However, watercolour
is less forgiving, so test it out first. If you buy a paint box, make
sure the brush keeps a sharp point and holds plenty of fluid. I
would recommend having two good-quality artists' brushes – a
medium, pointed brush for narrow paths and a large, pointed one
for broader patches. Natural sable-hair brushes are a pleasure to
handle, although not with acrylics. The best brushes to use with
acrylics are synthetic bristles, and they work well with other
paints, and are better value.

The colours used in the Lindisfarne Gospels were red and white
lead (red lead is a pale, warm colour), verdigris (grey-green), yellow
ochre, golden yellow orpiment, red kermes, brown-black oak gall,
denim-blue indigo, ultramarine lapis lazuli, and a variety of pinks
and purples. The colours are tinted with white for a pastel effect,
or thinned and applied as a wash. White or yellow was used mainly
for narrow edge bands, knots or paths; red, blue and green were
applied to the bodies; and red, black or brown as background.

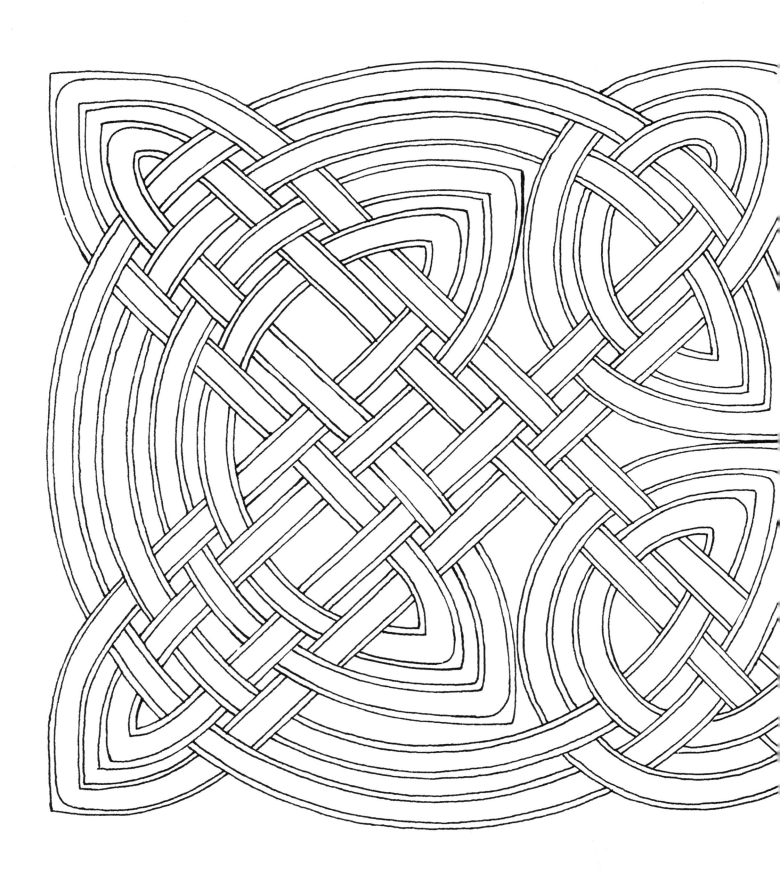

Folio 002v, 1

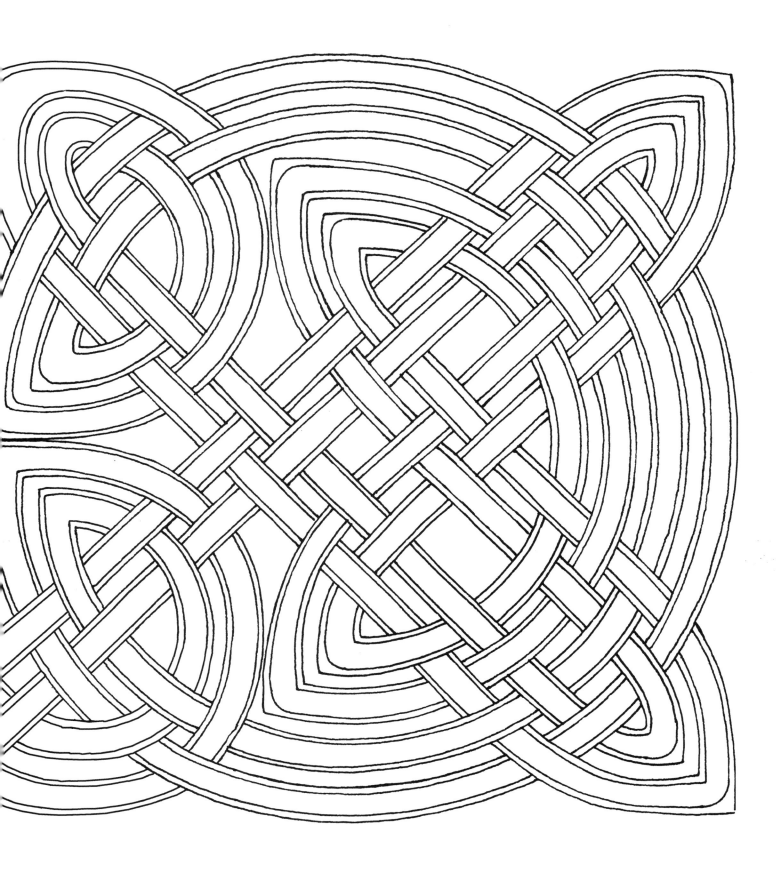

Folio 002v, a2

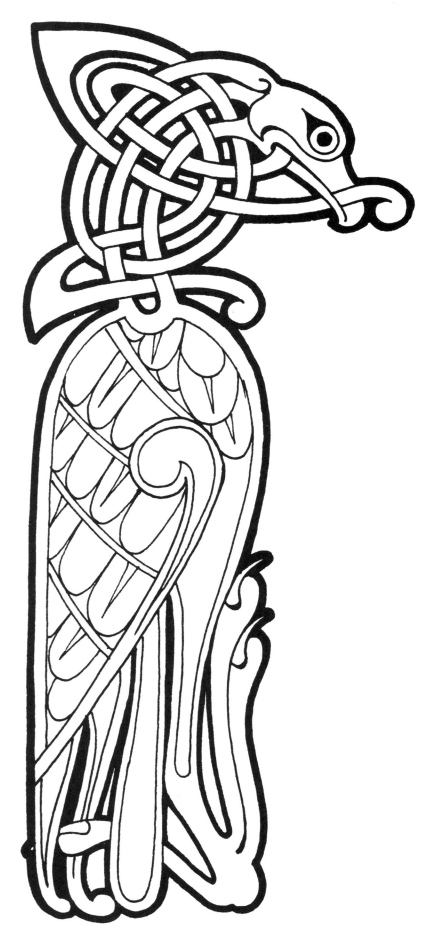

Folio 002v, b1

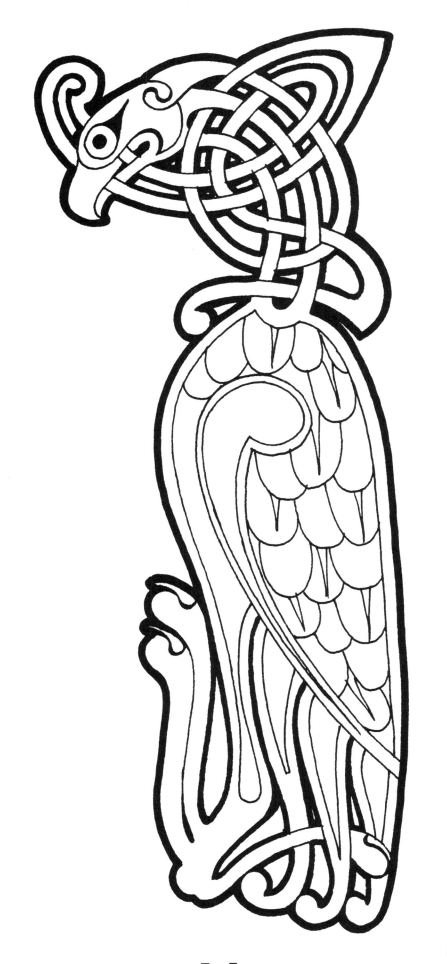

Folio 002v, b2

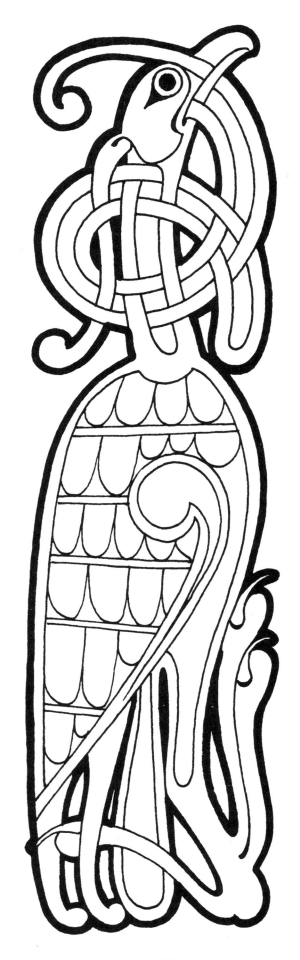

Folio 002v, c1

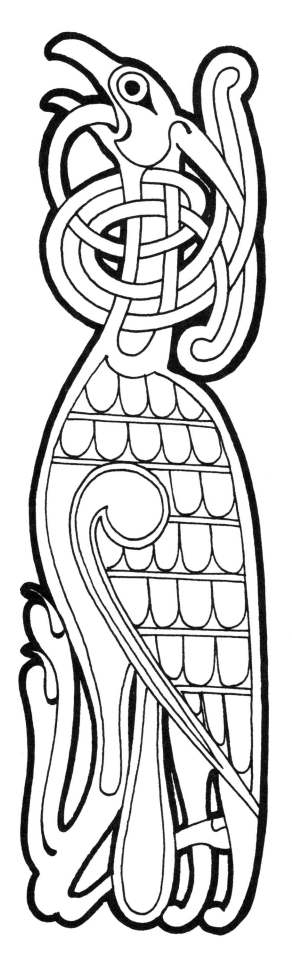

Folio 002v, 01

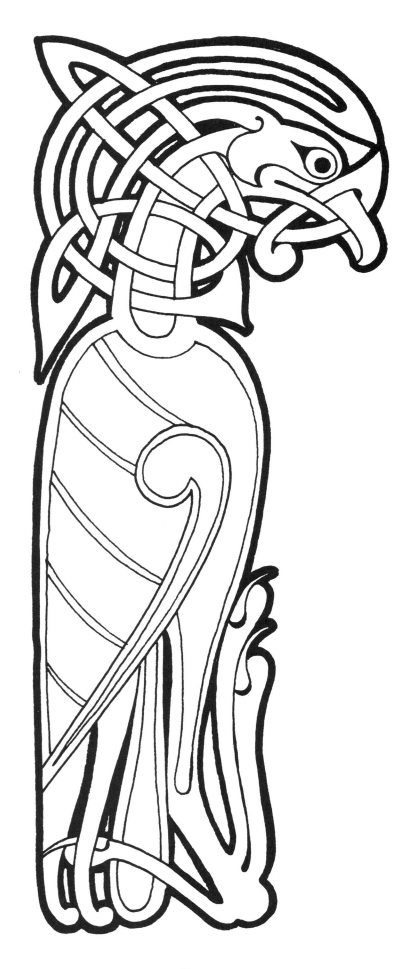

Folio 002v, e1

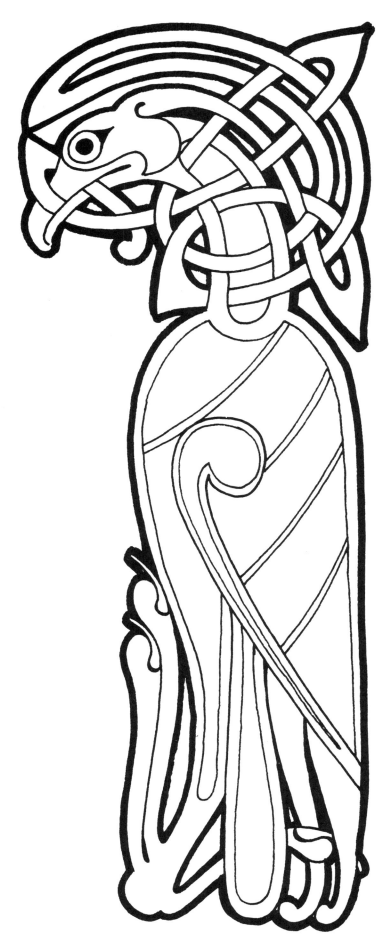

Folio 002v, e2

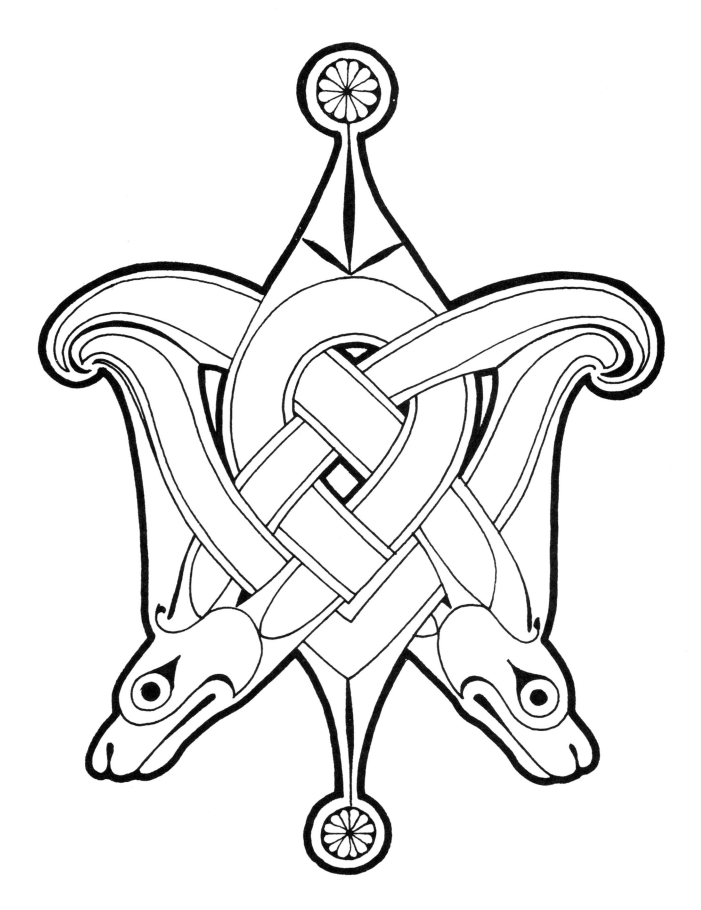

Folio 002v, F1

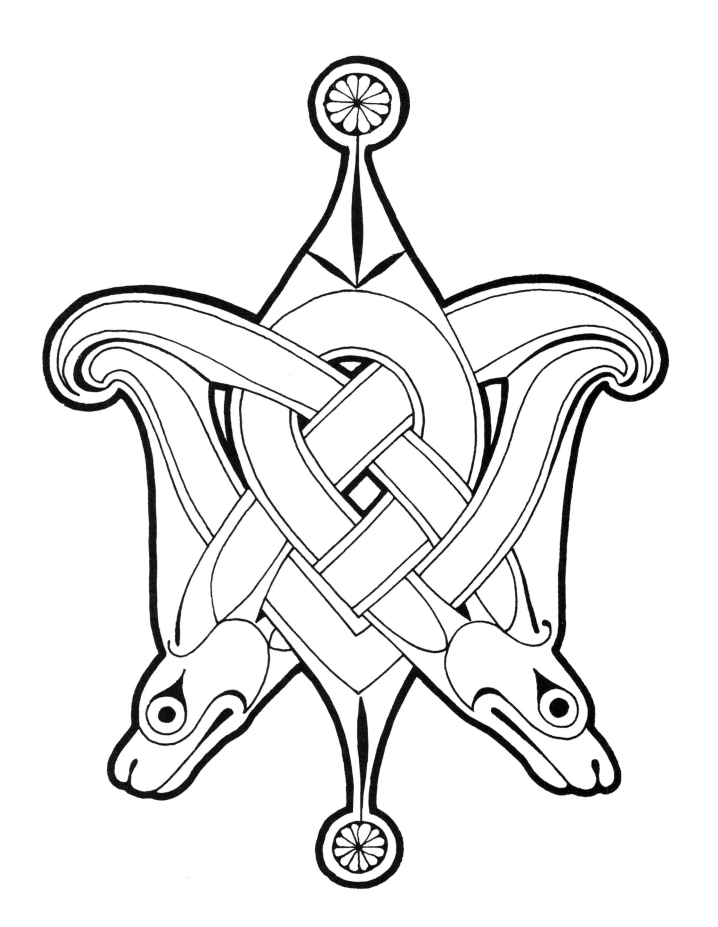

Folio 002v, f2

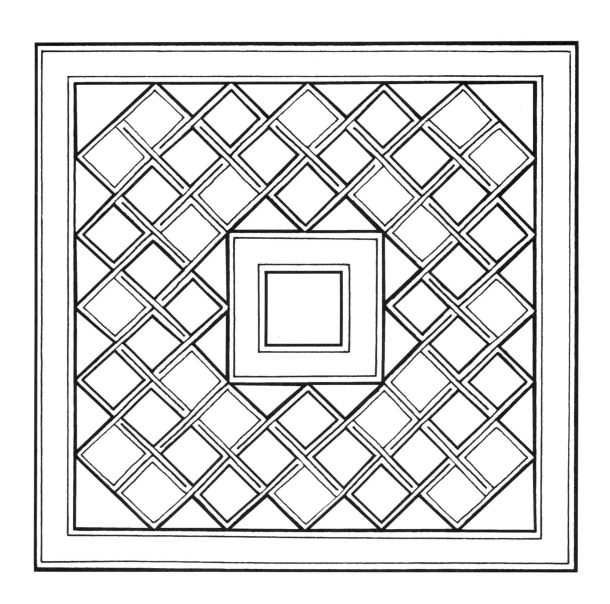

Folio 002v, ʒ1

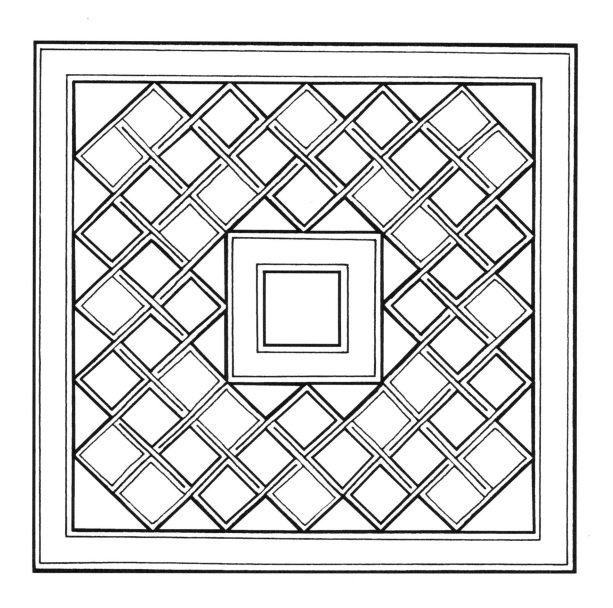

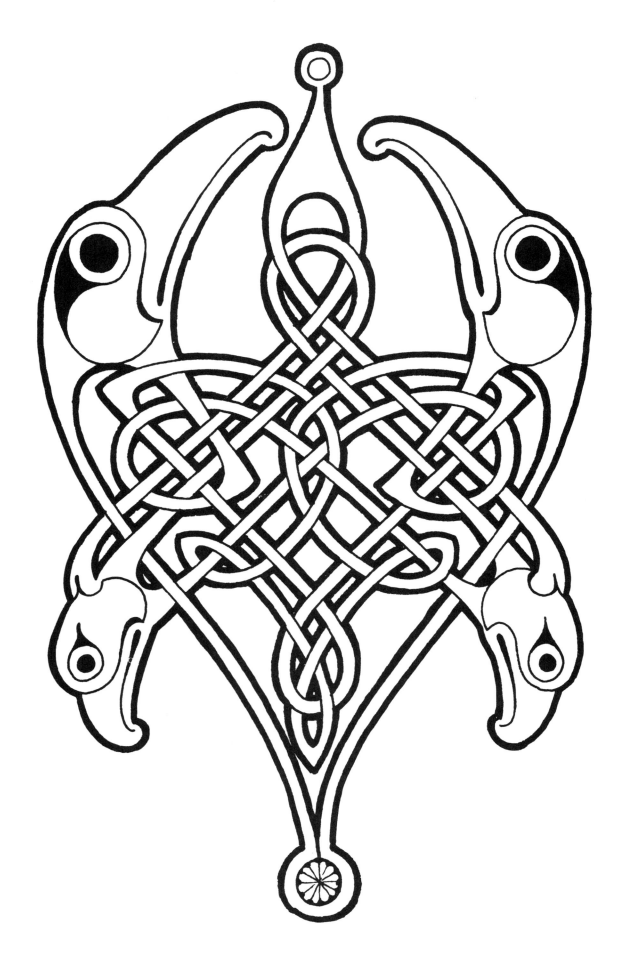

Folio 003R, A1

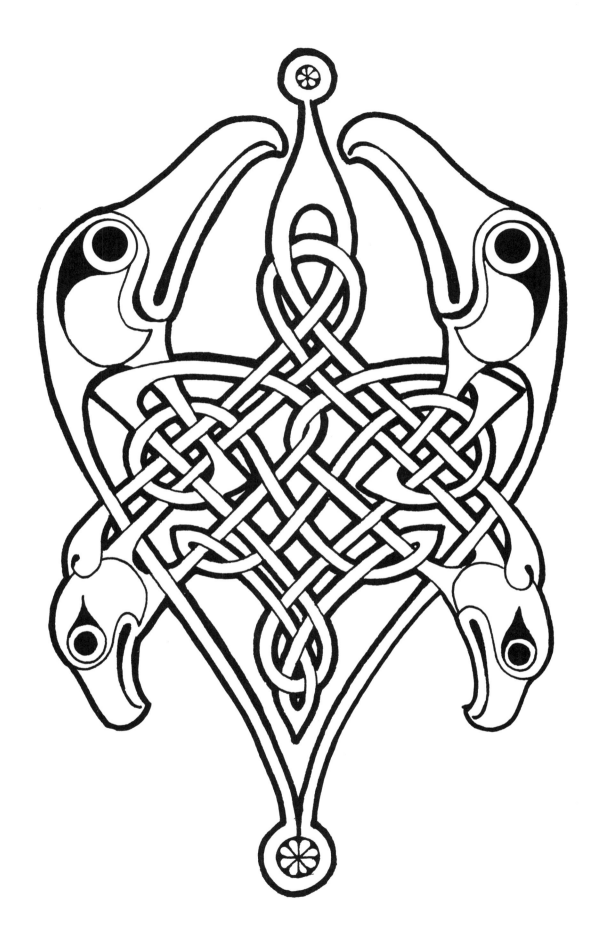

Folio 003R, a2

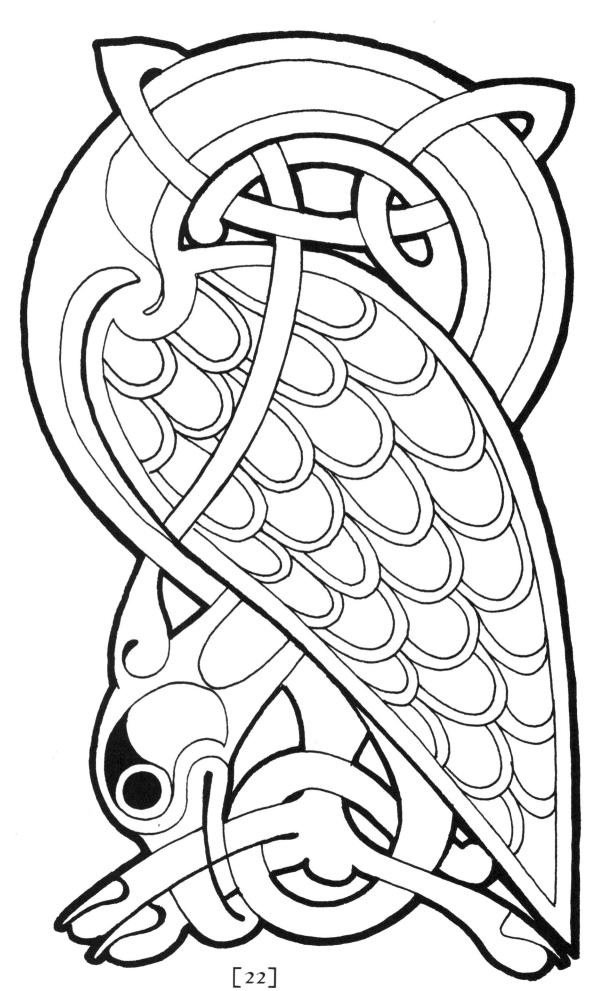

Folio 003R, b1

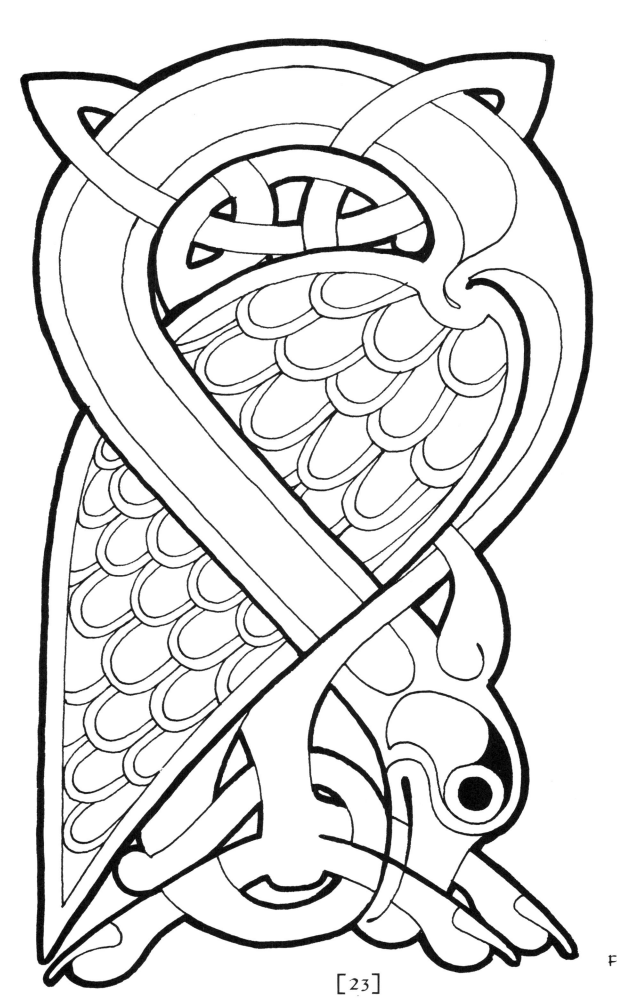

Folio 003R, b2

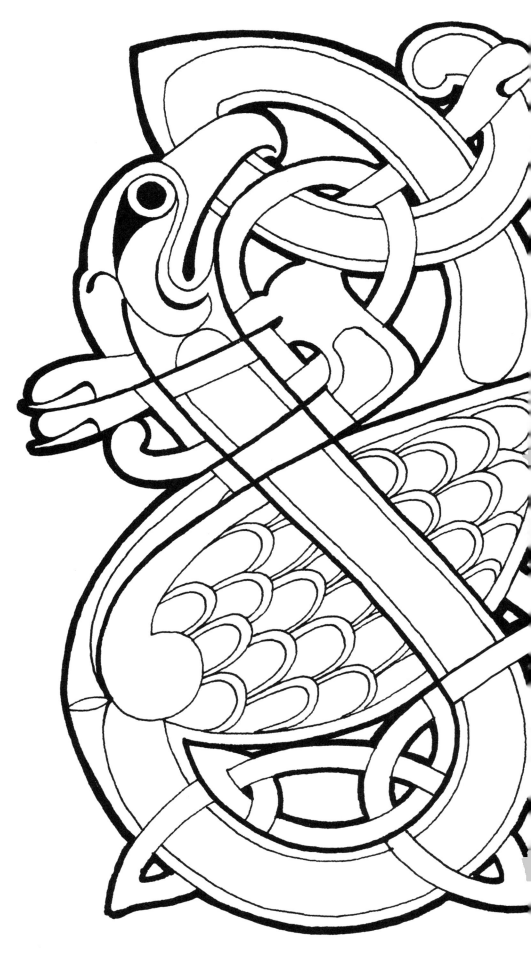

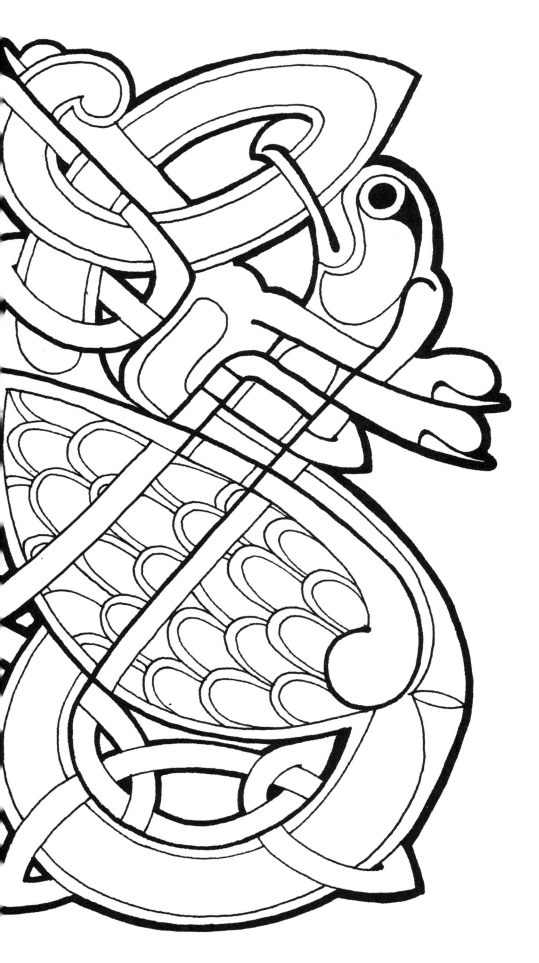

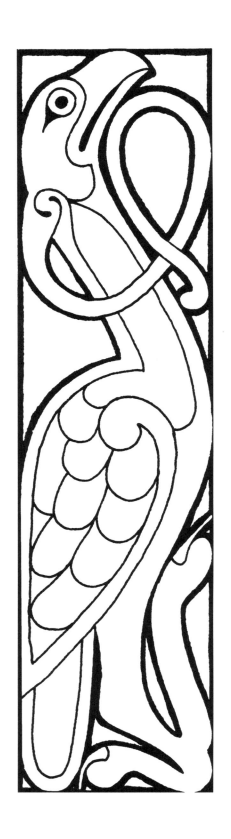

Folio 011R, A1

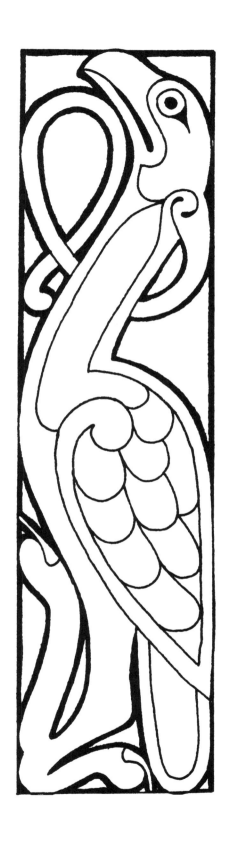

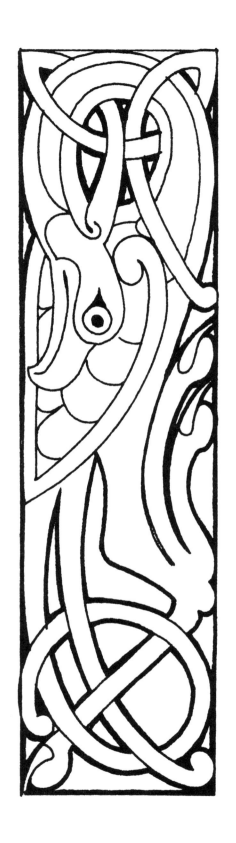

Folio 011r, b1

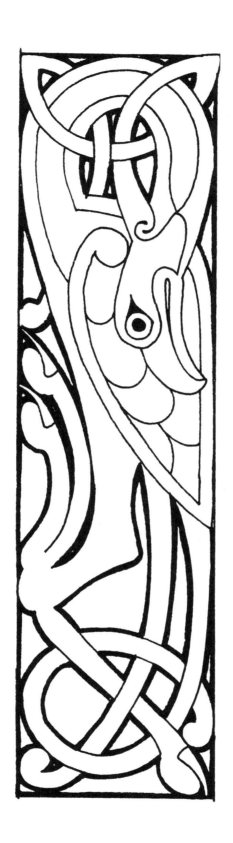

Folio 011R, b2

Folio 011R, c1

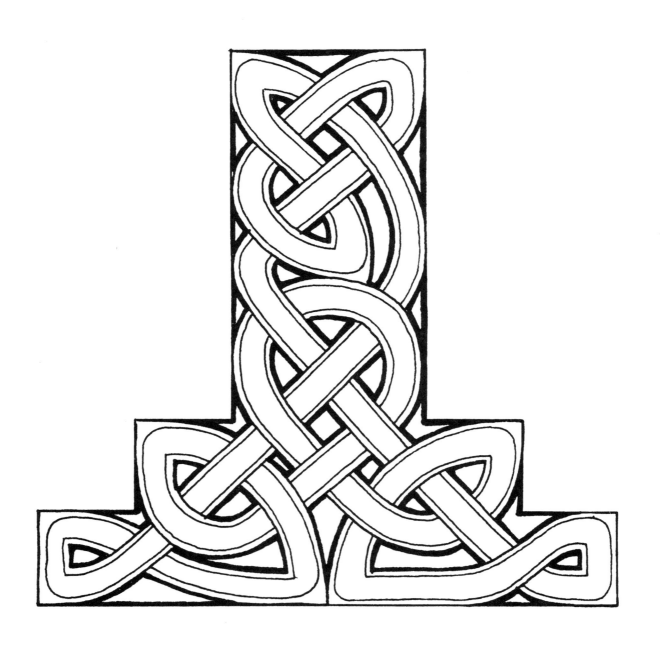

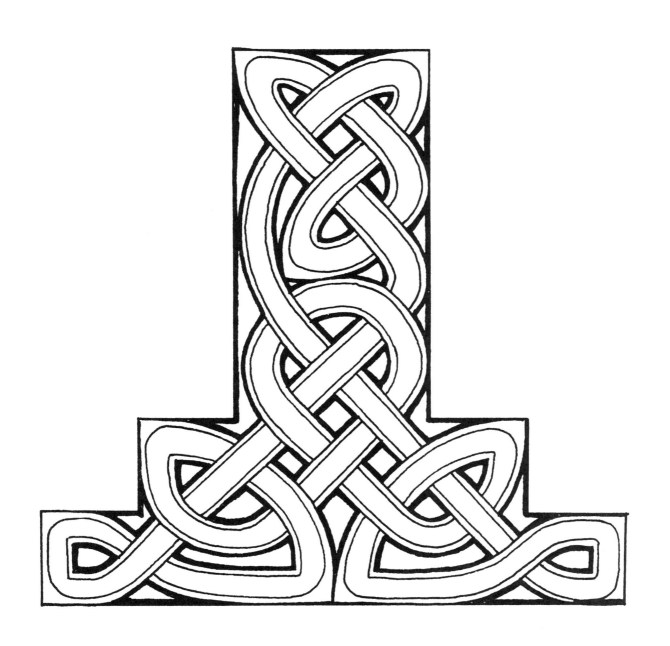

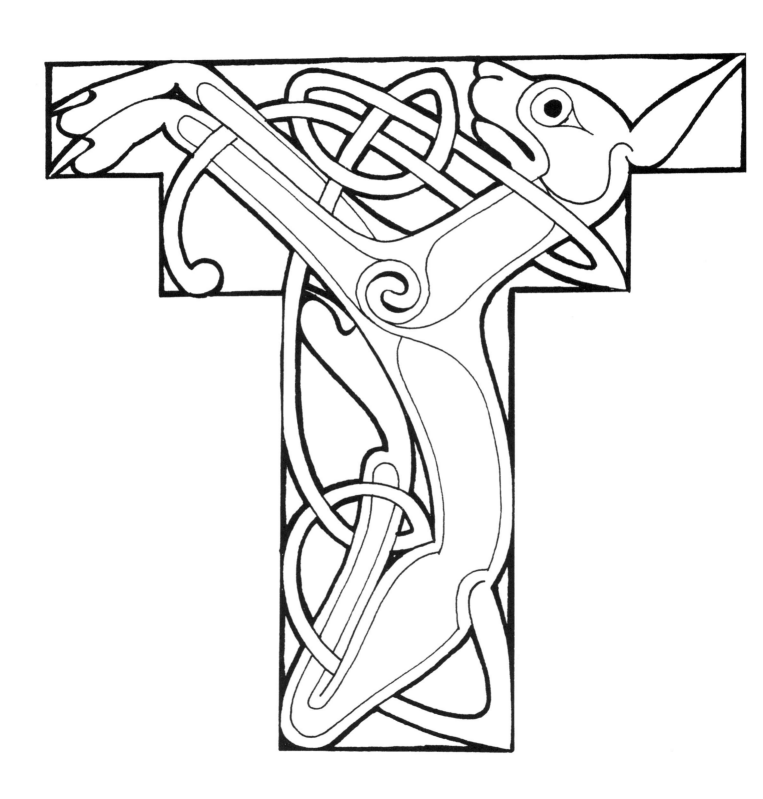

Folio 017v, a1

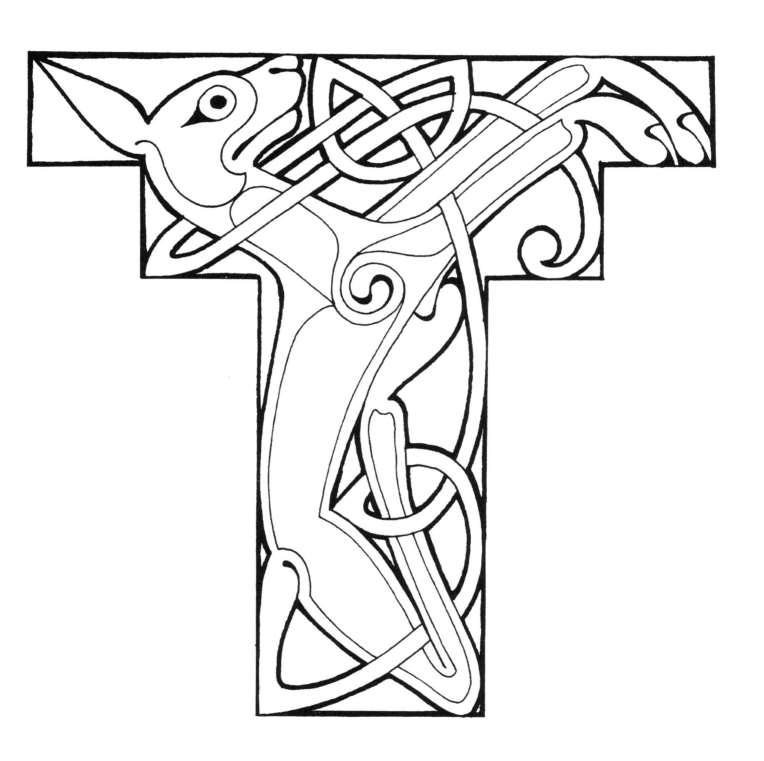

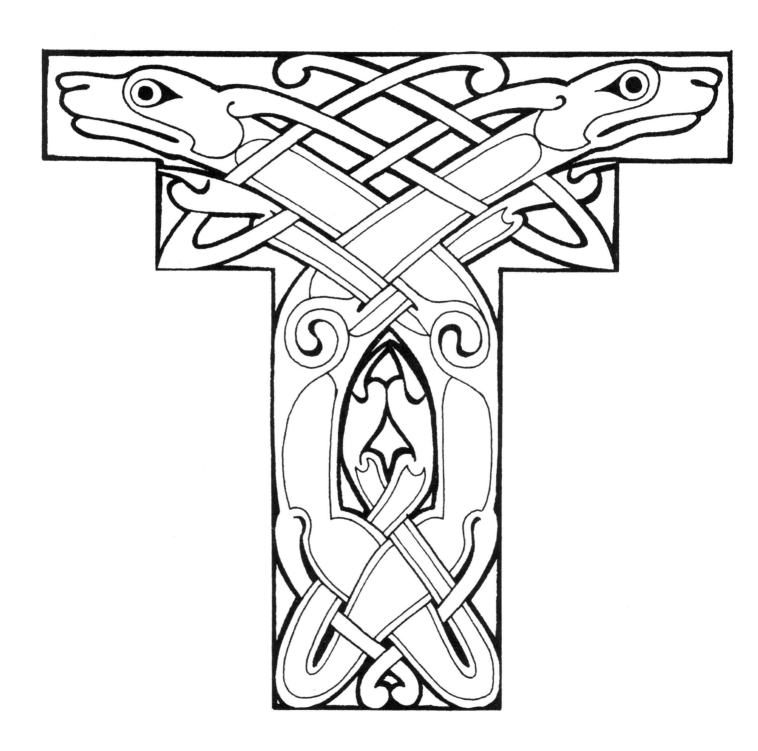

Folio 017v, b1

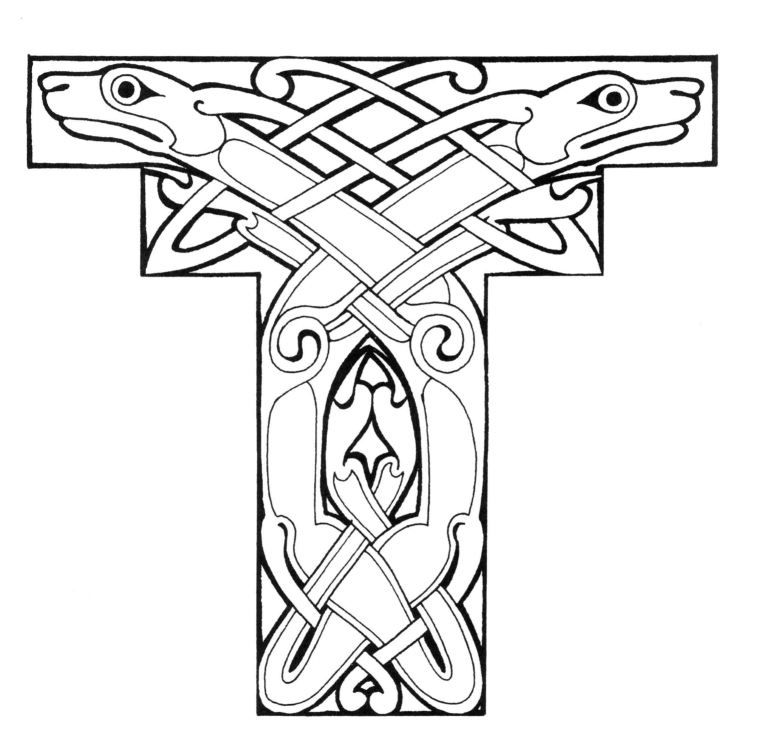

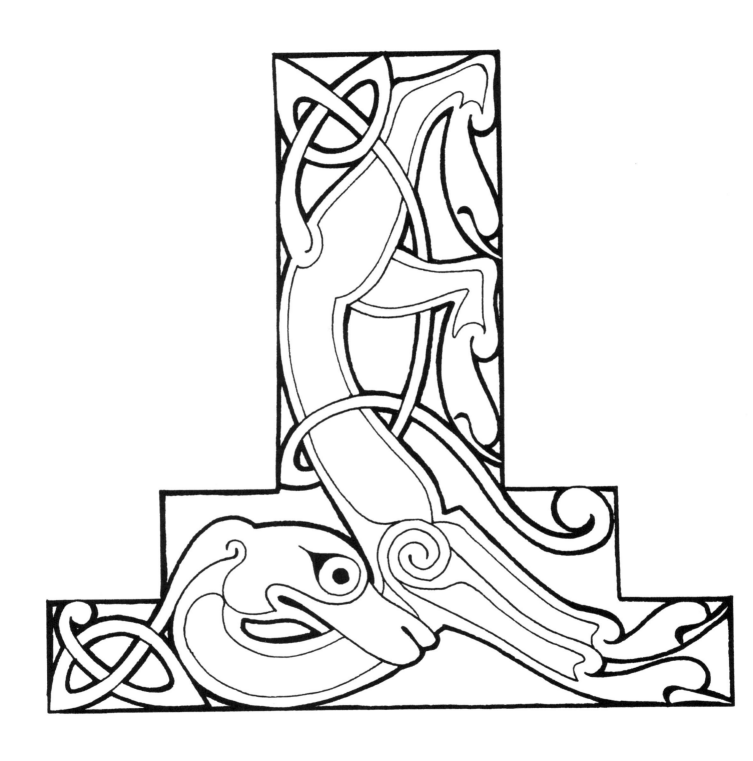

Folio 017v, c1

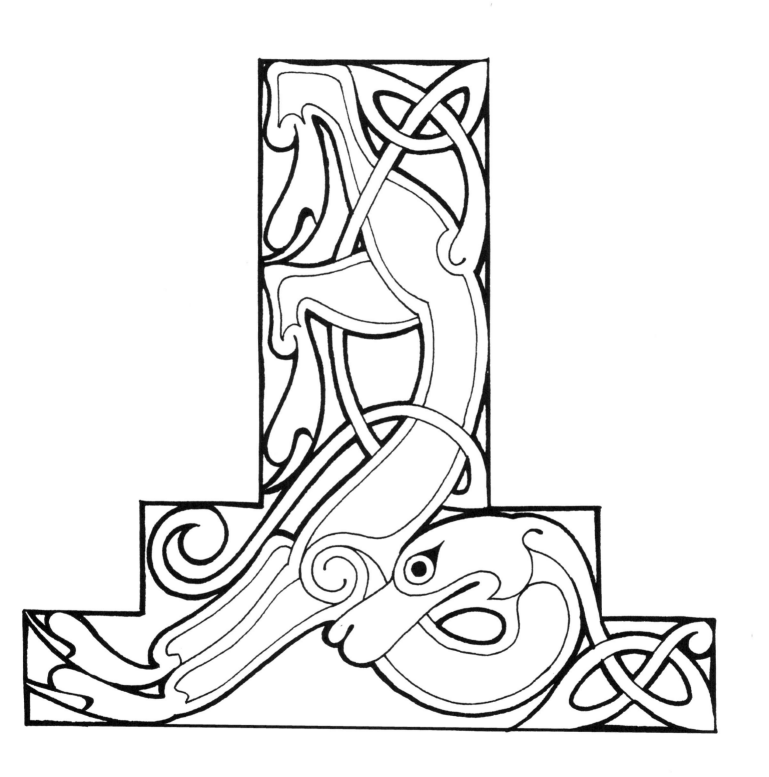

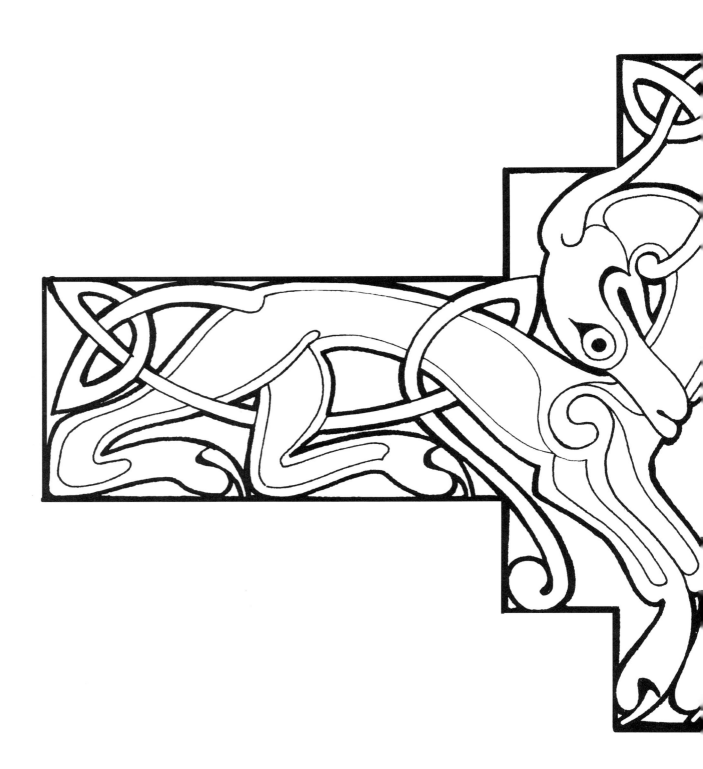

Folio 017v, ðI

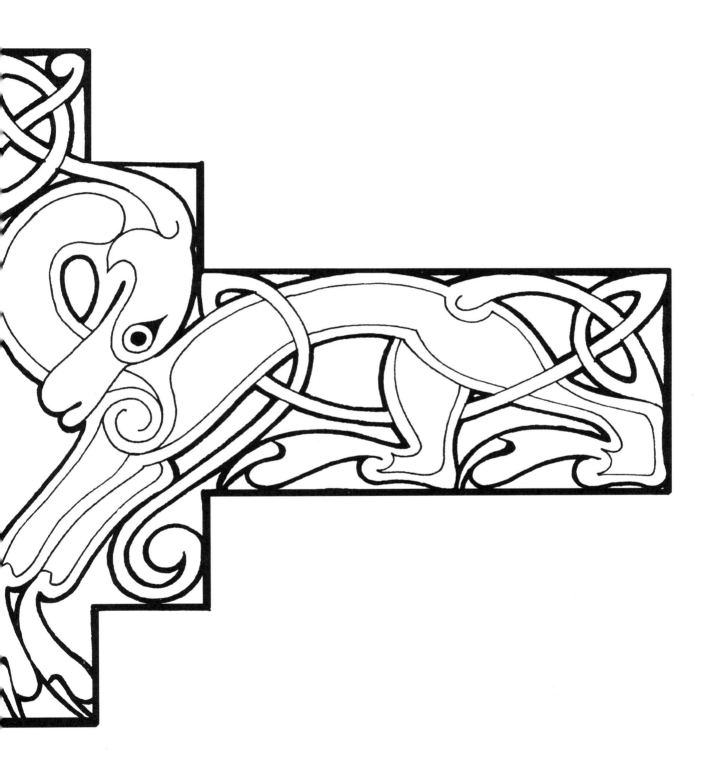

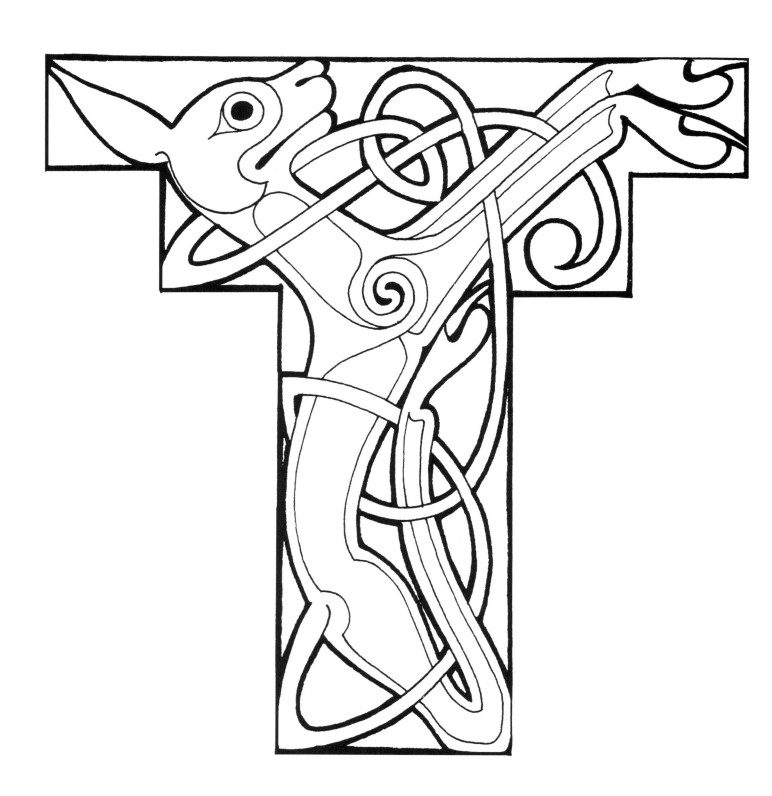

Folio 017v, e1

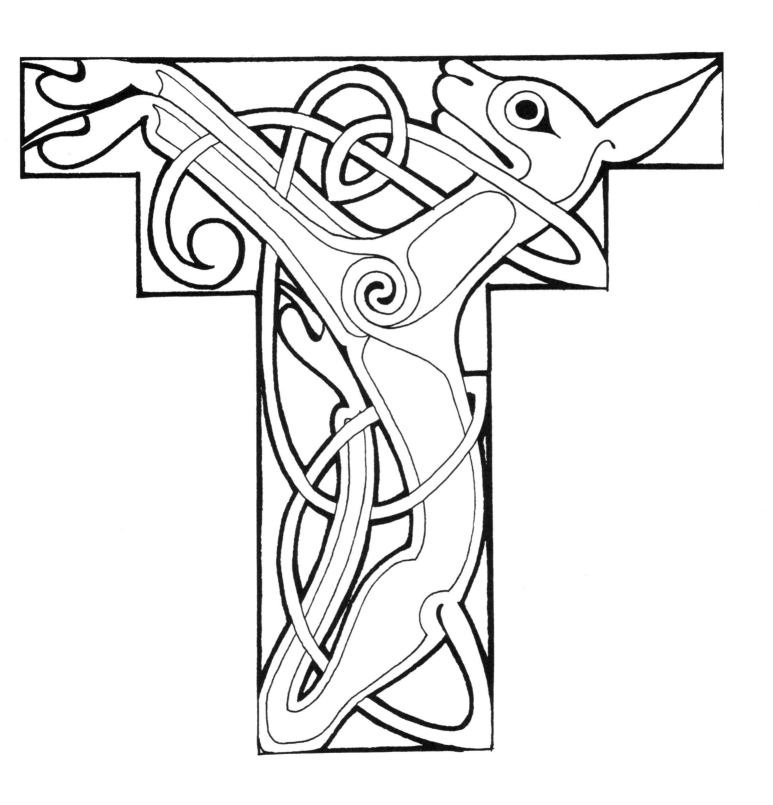

Folio 017v, e2

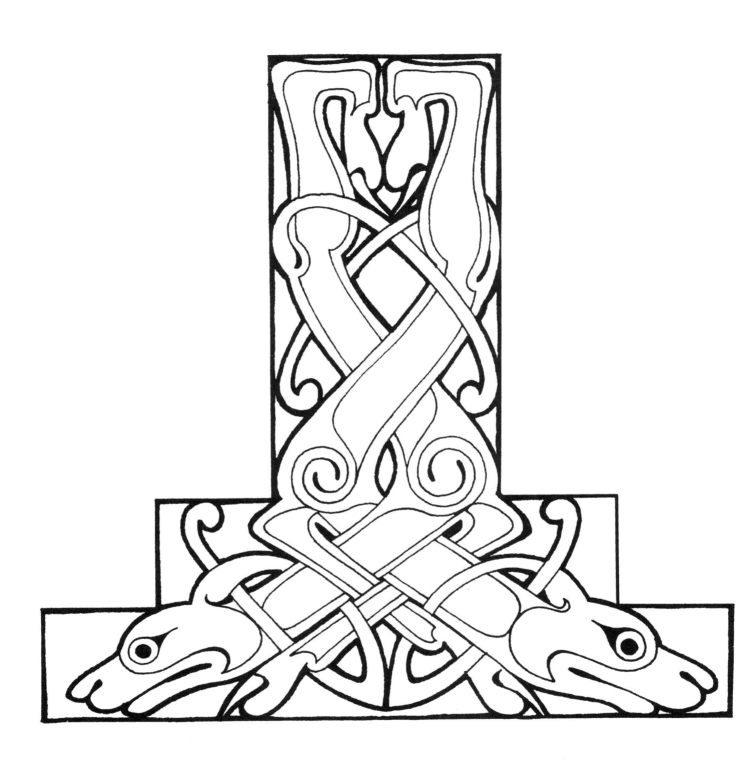

Folio 017v, f1

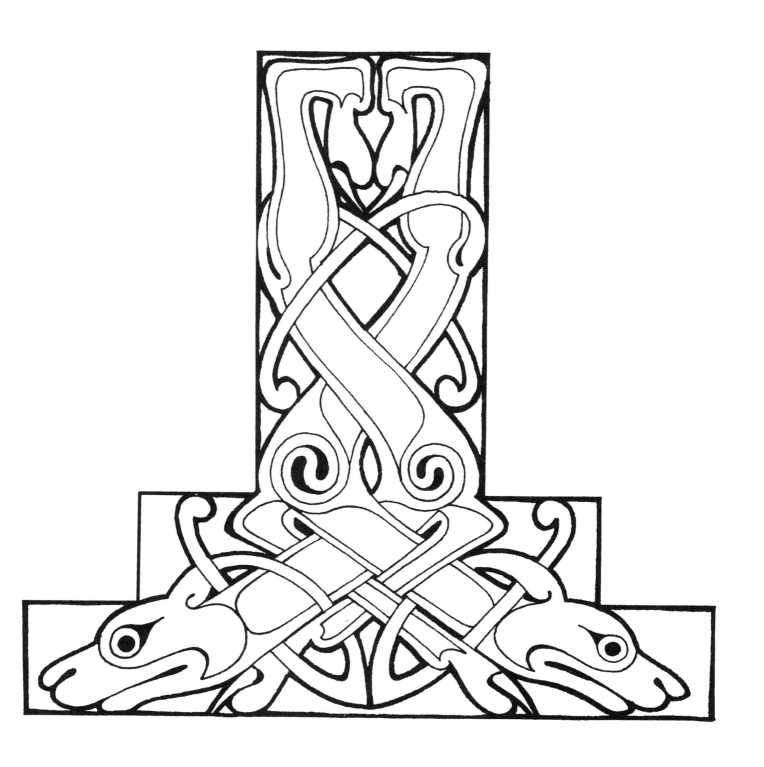

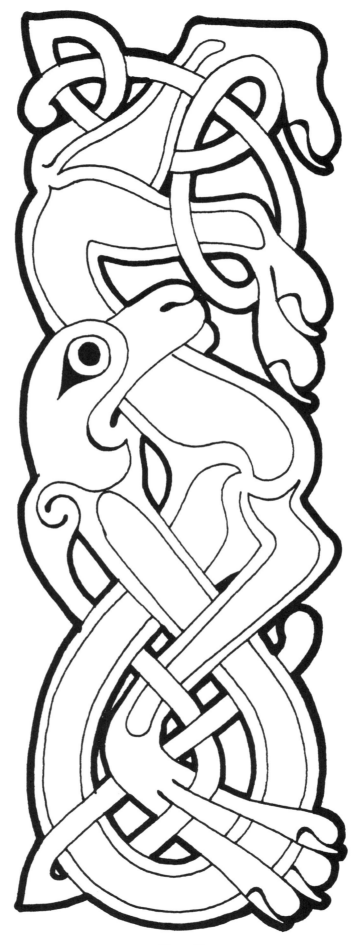

Folio 027R, A1

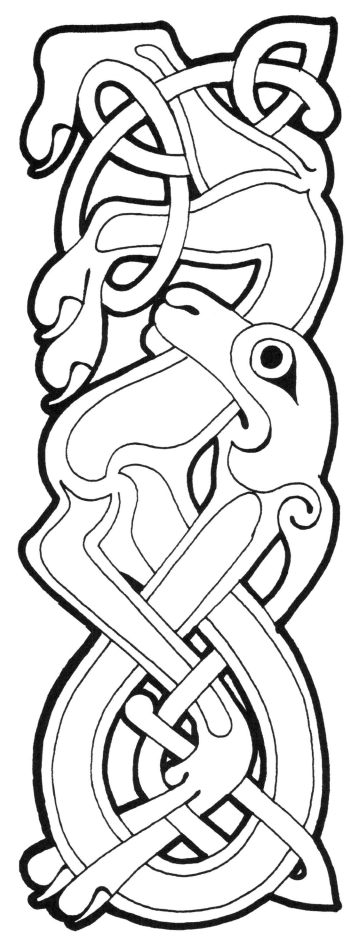

Folio 027R, A2

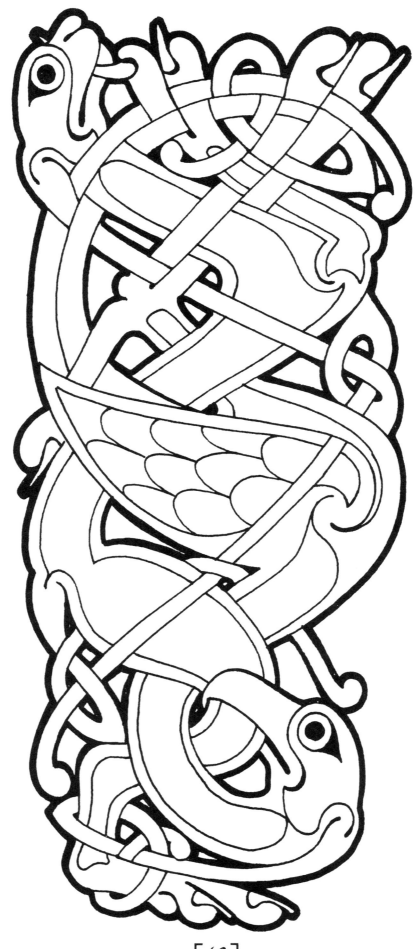

Folio 027R, b1

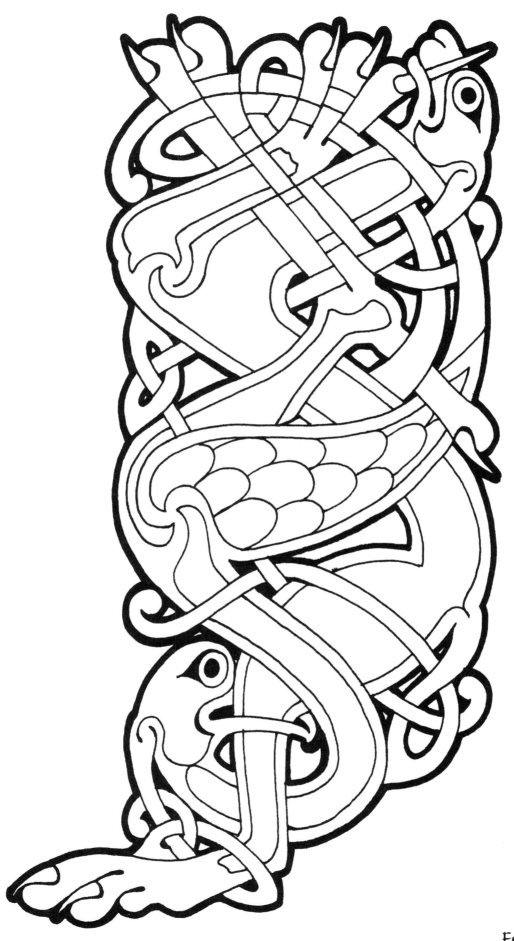

Folio 027R, b2

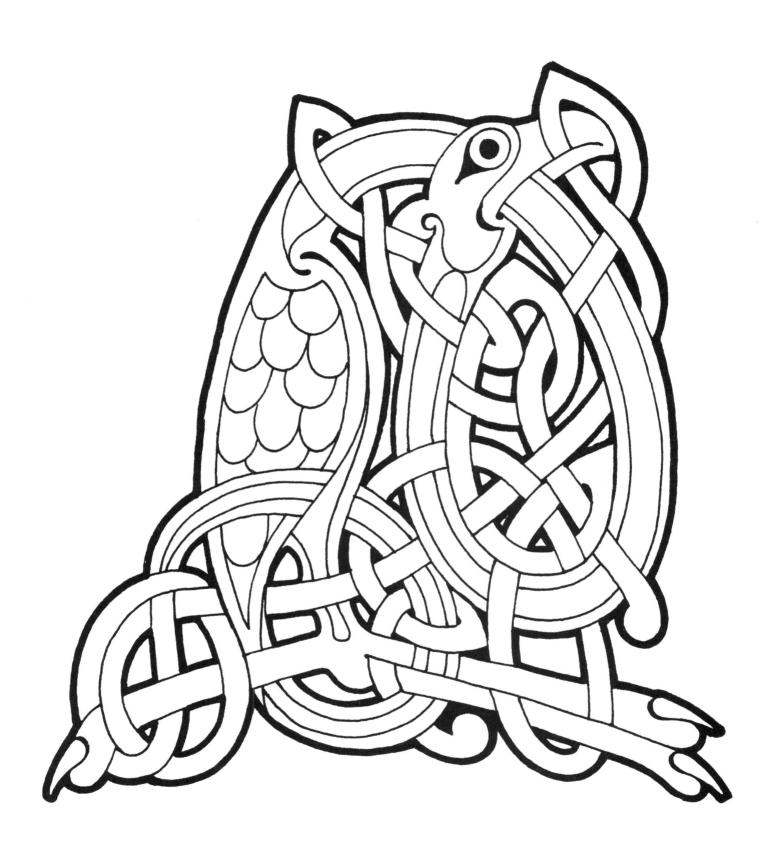

Folio 029R, a1

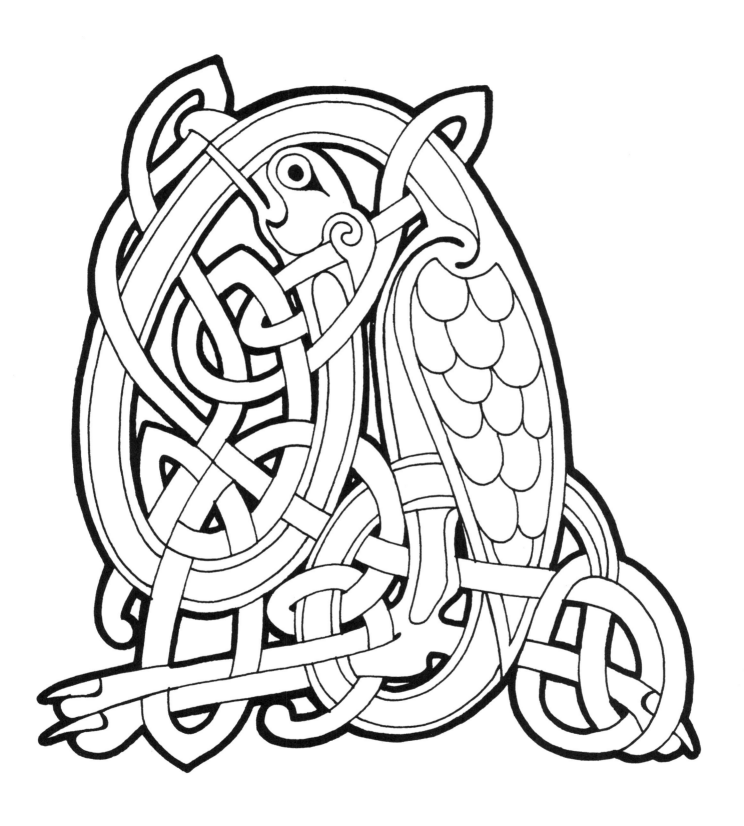

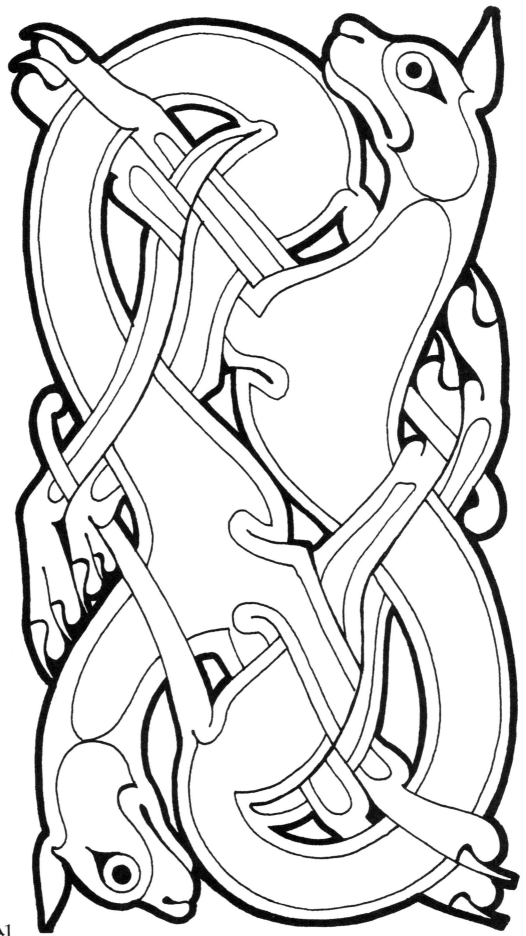

Folio 095R, a1

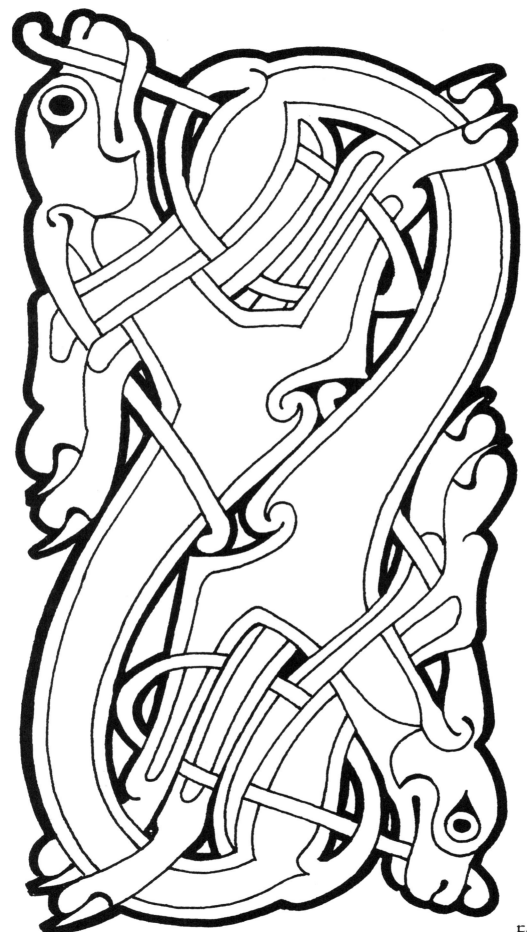

Folio 095R, b1

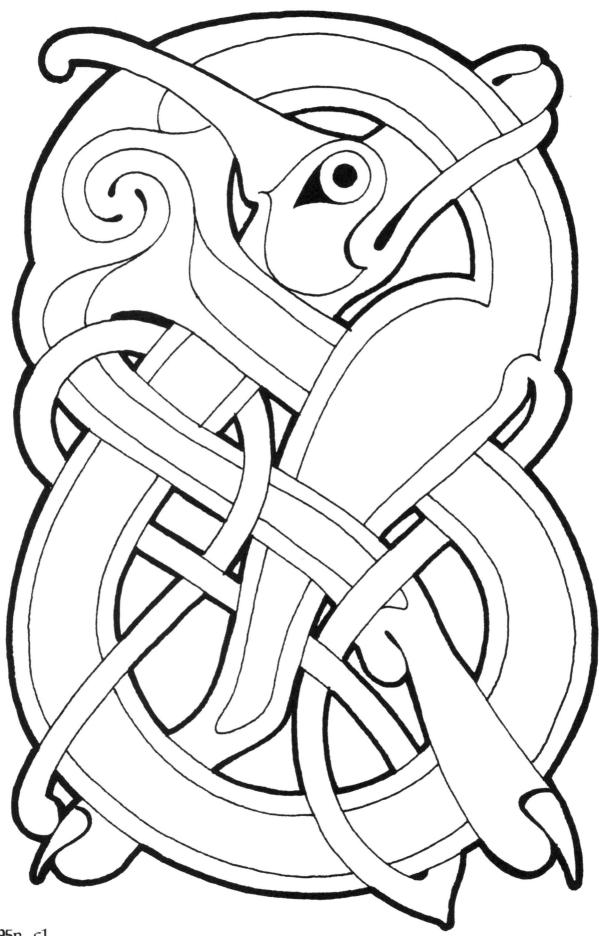

Folio 095R, C1

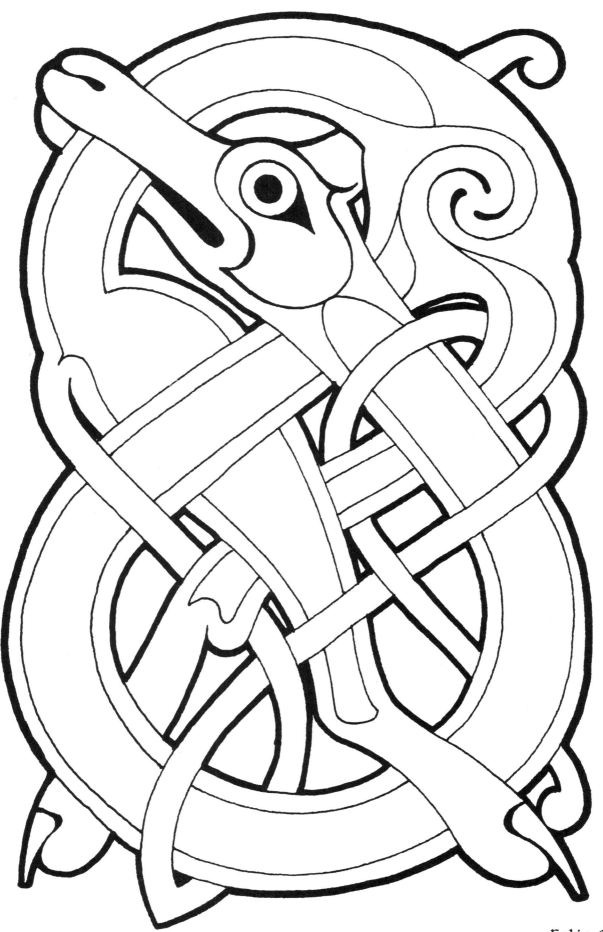

Folio 095R, c2

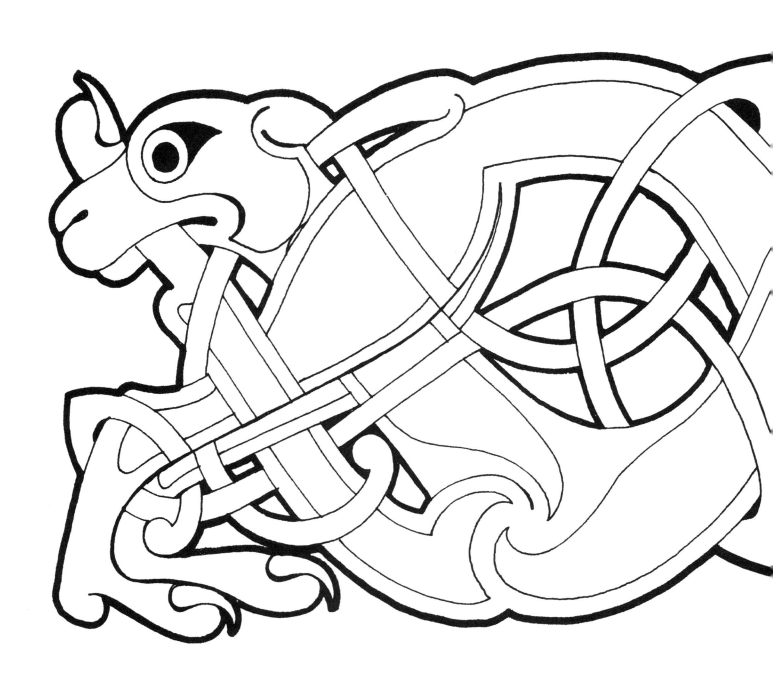

Folio 211R, A1

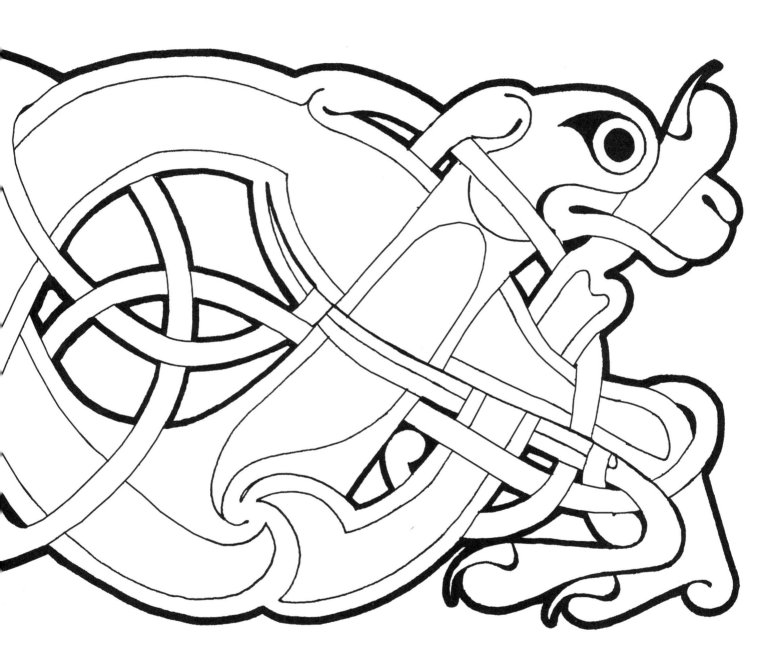

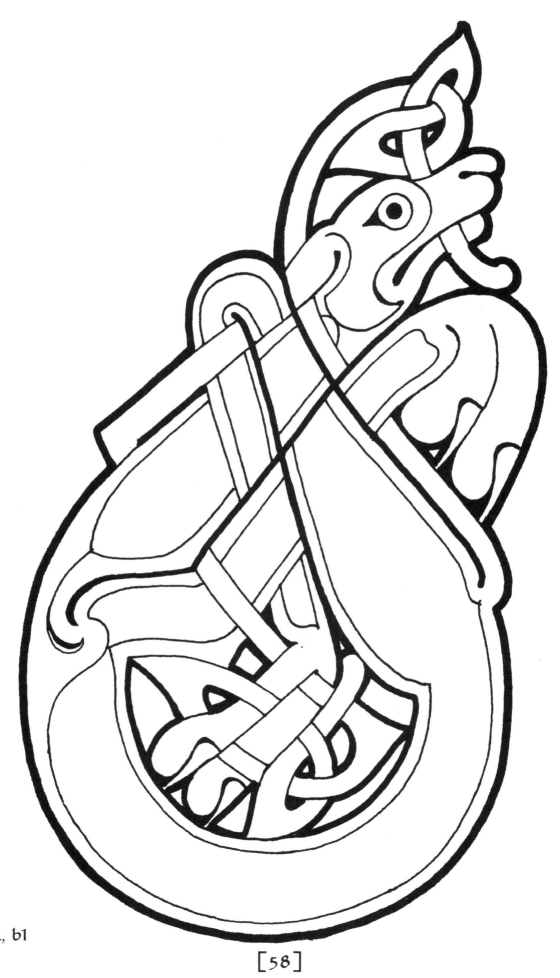

Folio 211r, b1

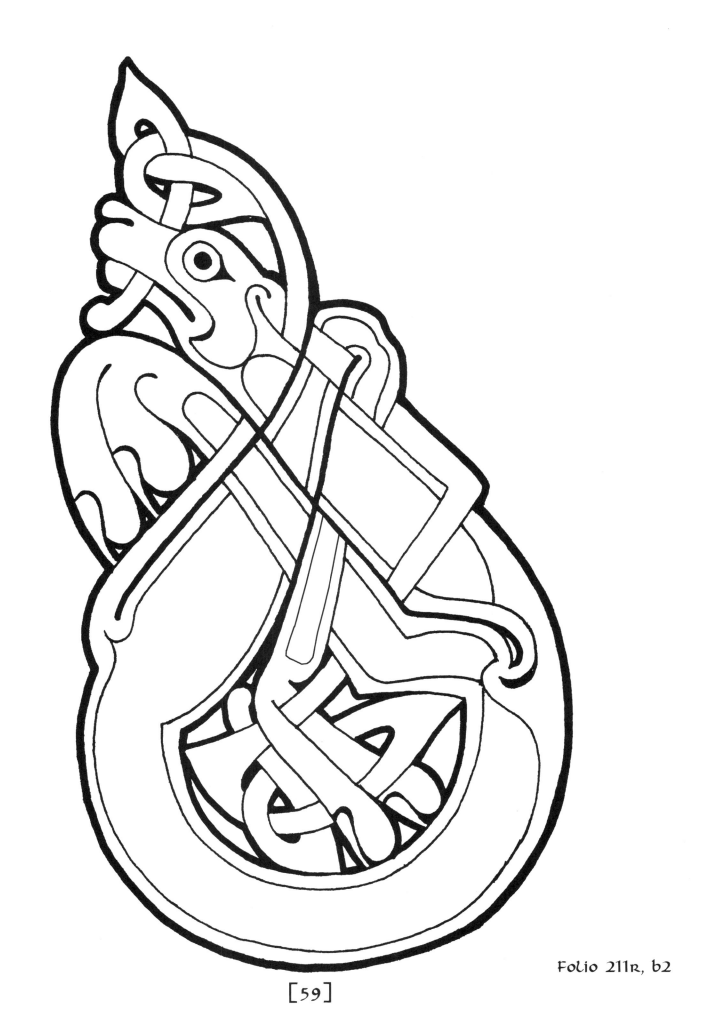

Folio 211r, b2

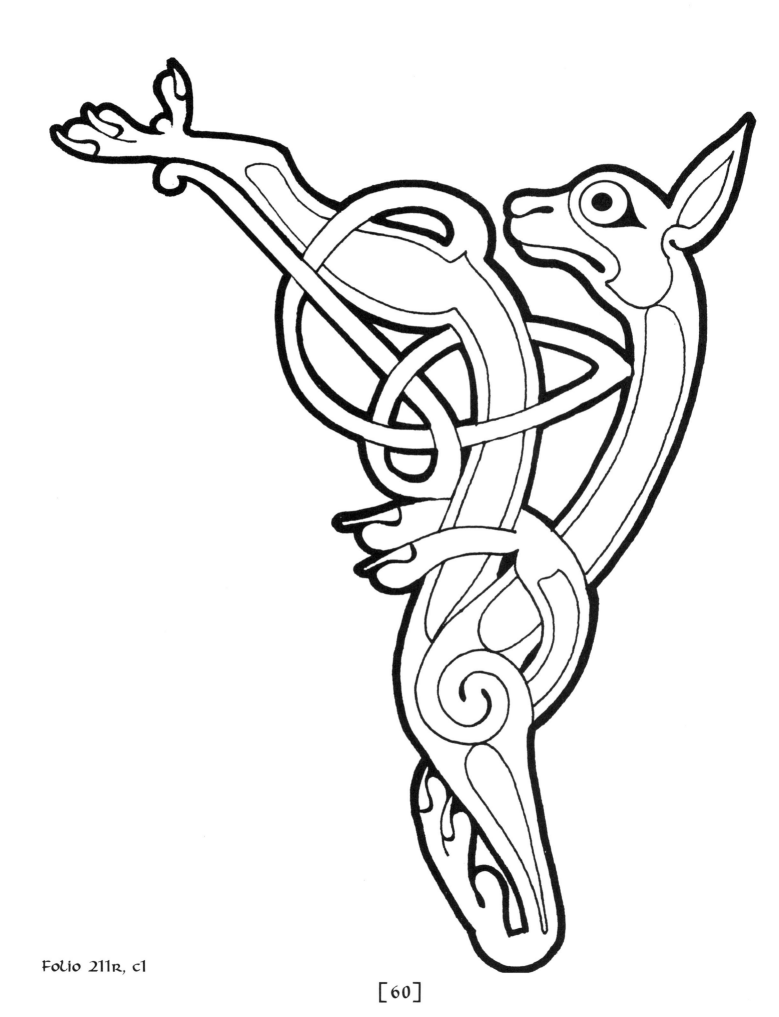

Folio 211R, c1

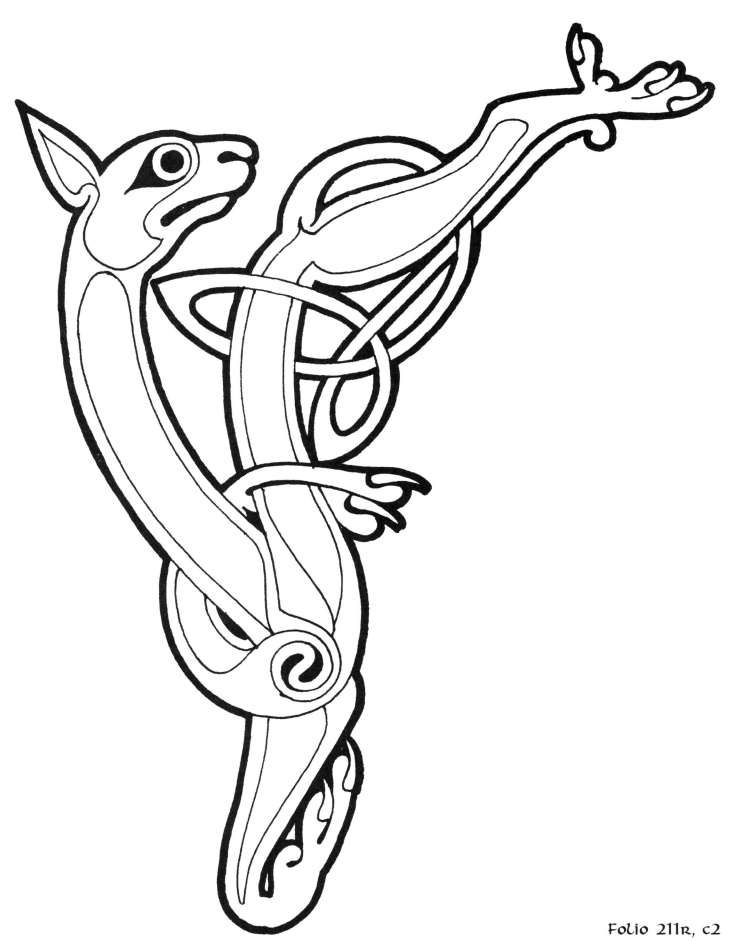

Folio 211R, c2

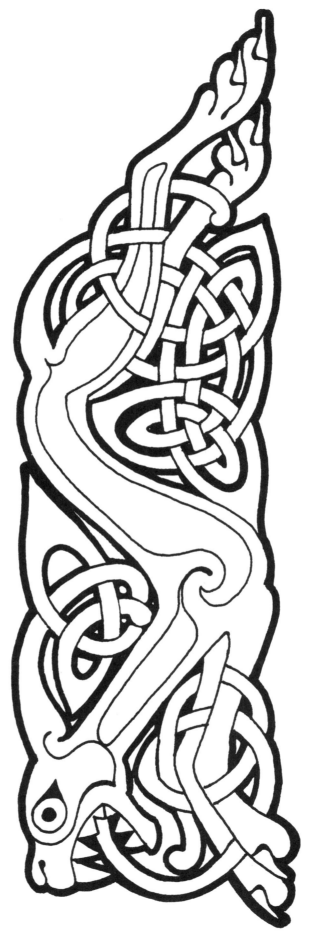

Folio 211r, 81

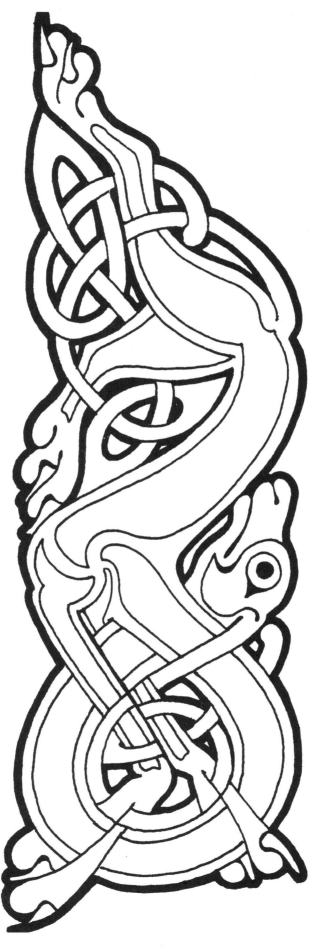

Folio 211R, e1

SOURCE BOOKS

Other books by Aidan Meehan with patterns from
The Lindisfarne Gospels:

Celtic Design: Animal Patterns
Celtic Design: Illuminated Letters
Celtic Patterns Painting Book (the title of the American edition
is *Celtic Patterns for Painting and Crafts*)
Celtic Alphabets
Celtic Borders
(all published by Thames & Hudson)

Janet Backhouse, *The Lindisfarne Gospels*, Oxford and New York, 1981